BEGINNINGS A Portrayal of the Creation

BEGINNINGS

A Portrayal of the Creation

Art by
Heinz Seelig of Haifa, Israel

Commentary by
Spencer Marsh of Portland, Oregon, USA

MULTNOMAH PRESS
PORTLAND, OREGON 97266

© 1981 by Heinz Seelig, Spencer Marsh
Printed in the United States of America

Library of Congress Cataloging in Publication Data

Seelig, Heinz.
 Beginnings, a portrayal of the Creation.

 Includes bibliographical references.
 1. Seelig, Heinz. 2. Creation in art. 3. Bible.
O. T. Genesis. 4. Bible. O.T. Genesis—Illustrations.
I. Marsh, Spencer. II. Title.
NE2373.7.S4A4 1981 769.92'4 81-18920
 AACR2

ISBN 0-930014-81-2 (pbk.)
ISBN 0-930014-82-0 (hd.)

Contents

The biblical account of the Creation narrative has inspired artists and writers for generations, and many have, with brush and pen, shared their inspiration with others. Heinz Seelig, a Jewish artist, and Spencer Marsh, a Christian theologian, share this inspiration in this unique book which eludes description. The distinctive style of Seelig leaves art critics reaching for words as they attempt to categorize his style. Some, observing the freshness and directness of his work, try to place him in the naive school of the Rousseau tradition. Such an attempt is fruitless because Seelig cannot be classified; his style is distinctly his own.

Much the same is true with the writing of Spencer Marsh. Neither purely scientific, theological, nor poetic, it, like Seelig's art, is a response from the heart to this timeless story. Marsh says, however, he feels especially blessed because he had two sources of inspiration: the biblical narrative and the paintings of Heinz Seelig.

Spencer and Doris Marsh and Heinz and Fanny Seelig first met in Haifa at a very significant time in history: the spring of 1978 when the peace treaty between Israel and Egypt was signed. The Marshes had just come from visiting Egypt where the passengers on their ship had been welcomed at the port of Suez by a large sign which read, "Welcome to Peace Land." As they traveled through the Suez Canal enroute to Haifa, they could feel peace in the air as the Egyptian and Israeli soldiers on opposite sides of the canal were already responding to one another in new and more peaceful ways.

It was during this peace season that President Carter of the United States and President Sadat of Egypt each received gifts of the paintings in this book in the form of seven lithographs. Appropriate gifts they were because the peace these men sought, along with Prime Minister Begin, is the same peace the Creator and His creatures knew on that seventh day of Creation when all was well in God's family. May we know that same peace again.

"In the beginning
God created the heavens
and the earth. "
Words not to be improved upon
but neither must their familiarity
lessen their impact.
Here begins the narrative of
the imponderable mystery of creation
expressed in words and stories
as simple as language permits.
Words and stories of faith
which are told with
the same assurance and conviction
as the young college student who declared,
"Of course there is a God;
do you think the world made itself?"

Introduction

Sharee was just a child when she taught me, her theologian father, how to read the first chapter of Genesis.

As a gift for her tenth birthday, she had asked for (and received) a trip with me to the Oregon coast. After spending the night in a beachside motel, the two of us arose early in the morning to enjoy a day-long walk by the ocean's edge. We would search for sand dollars and gaze into the silent tidepools, those tiny suburban communities of the sea.

But before we left our room that quiet, foggy morning, I picked up the Gideon Bible and asked, "How about reading something from the Bible before we start our day?"

Sharee's "Okay" was not exactly an affirmation of the idea. But when I asked her if she had a favorite passage, her attitude changed from "this shouldn't take too long" to an expression of genuine excitement.

"Oh yes!" she said. "I just love the very first part. About how the world was made. That part is *so beautiful.*"

Those few words from my little ten-year-old girl were a revelation to

 9

me. How many times had I looked at that passage? Having laboriously studied those verses to get a clear understanding of the Creation, I had often wrestled with the weighty questions of this important passage: "Length of days?" "Evolution?" "Devolution?" "Big bang?" "Proper order of days?" "Formlessness and voidlessness?"

And so it went—hour after hour of arduous study. Weary days of searching out geological and biological answers to questions I have long since forgotten.

Yet somehow, through all the complex matrix of study and research, Sharee's perspective had slipped through my fingers.

"It's so beautiful!"

I watched my daughter settle into the big chair by the fog-curtained window. I saw her face light up with anticipation as she waited to hear her "beautiful, favorite part" of the Bible.

I began to read. The Creation story from Genesis. And I read it with a new set of eyes and a new set of ears: the eyes and ears of a little child. For the first time, I felt the beauty. It was there. So poignant I wondered that I could have missed it through all those years.

That sense of awe and wonder lingered with me as we crossed the sand to investigate this Creation of which we had just read.

I experienced some of those very same feelings when I first saw Heinz Seelig's paintings of "The Seven Days of Creation." They are clear evidence that this mature and wise man has never let the child in him die. For who but a child would be comfortable enough with the reality of God to portray Him in a picture?

If you are willing to see again through the eyes of a child—does the child in you yet live?—you will behold in these paintings the beauty of

God's joyful, colorful, awesome Creation.

Remember in *The Wind in the Willows* when Rat and Mole first heard the haunting, heavenly music of Pan, the animal's god? As they drew near to the music's source, "suddenly the mole felt a great awe that turned his muscles to water, bowed his head and rooted his feet to the ground. It was no panic terror—indeed he felt wonderfully at peace and happy—but it was an awe that smote him and, without seeing, he knew could only mean some August Presence was very, very near."

For me, the combination of the words of the biblical Creation narrative and these paintings of Heinz Seelig produce the same kind of awe.

The Creator is near. Very, very near.

 11

⁓ The Main Character ⁓

To the writer of the Bible's carefully honed Creation narrative, God is an unshakeable certainty. There is no attempt to prove His existence; only to reveal the character and attributes of this One who is utterly beyond our comprehension. We would not know Him or anything about Him had He not chosen to reveal Himself to us. Obviously, He has not revealed everything and yet it is amazing how much we can learn about Him in the relatively few words of Genesis, chapter one.

He Is a Creator God. Humanity, up to the time of the recording of this Creation account, believed in lesser gods—as many still do. Man has created gods of the storms, the sea, the earth, and the seasons. But here is a God who is the Creator of storms, seas, and seasons. As in each of the paintings, He is over and above it all, including time itself because at the beginning He already is.

Other gods are often identified and confused with the Creation, as if they were one and the same. But not this God; He is not the same as His Creation. This does not mean He leaves it unattended. As the paintings portray, He is always there with His Creation. He is the Creator God, a God who continues to create and recreate—even us, if we let Him.

He Creates with His Word. Words are powerful. But none so powerful as those of the Creator. When He creates His world He uses no tools of any sort; no magic wand, no test tubes and flasks, no cranes, earth-movers, incubators, or greenhouses. His powerful, authoritative, commanding, creative Word is enough.

 13

He said, "Let there be . . . and it was so."

It sounds unbelievable but there are those who walk this earth and have discovered He still utters His creative Word. When they listen, their ways are changed, their hearts cleansed, their paths lit, and their lives made whole.

Even though we would not want to damage the total uniqueness of his Word, we are prone to make comparisons between the power of His Word and the power words can have in our lives. Remembering the recognition of her first word, Helen Keller said, "All at once, there was a strange stirring within me, a misty consciousness, a sense of something remembered. It was as if I had come back to life after being dead!"

What that first word did for Helen Keller, His incomparably powerful Word does for us . . . if we listen.

That Which He Creates Is Purposeful and Orderly. In the Creation account we see the movement from chaos ("without form and void") to order. By the seventh day things are in their proper place, functioning according to their purpose. There is a rhythm of order—"evening and morning"—and numbering of days. In addition, purposeful assignments are ordained. The sun is to rule the day; the moon will rule the night. Man is named caretaker of the earth.

The clearly evident order of God's Creation is so dependable that man has been able to observe, gather data, and write down laws, the accumulation of which we call *science.* This makes scientists, according to Arthur Koestler's way of thinking, "Peeping Toms at the keyhole of eternity." Looking at it from that point of view, the naturalist Agassiz qualifies as a scientist in the best sense of the term. It is said that he began each of his lectures with the words, "Gentlemen, we shall now think God's thoughts after Him."

This order and purpose in Creation not only allows for science, it also makes *planning* possible. We can plan for the future; we can plan on getting up tomorrow morning because we know there will be a tomorrow morning. This would not be possible were it not for the Creator God of order and purpose Who continues to be involved with His universe. G. K. Chesterton said it well: "The sun rises because God says to it, 'Get up.' "

That Which He Creates Is Good. It was almost as if the writer anticipated people coming along who would not appreciate the goodness of God's Creation. So he made the point emphatic, repeating it three times: *"and God saw that it was good."* For final impact he added, "and God saw everything He had made, and behold, it was *very good."*

The Hebrew word translated "good" is used to communicate God's satisfaction with what He

had created. It was pleasing to Him, and should rightfully be pleasing to us. Humanity has generally not had a proper appreciation for God's Creation. Forgetting its Author, we have treated it like an enemy to be battled rather than the good work of His hands to be prized. We have become curiously out of tune, somehow, with the Creation of which we are a part. The time has come for us to consider our relationships, not only with God and our fellow man, but also with the rest of His Creation.

There is a part of a Sabbath service which I am sure was written by one who was discovering a right relationship with the Creation and found it to be, as Genesis says, "very good."

"In the hour when the Holy One, blessed be He, created the first man,
He took him and let him pass before all the trees of the Garden of Eden,
and said to him:
'See My works, how fine and excellent they are!
Now all that I have created for you have I created.
Think upon this, and do not corrupt and desolate My world;
for if you corrupt it, there is no one to set it right after you.' "[1]

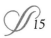

First, there is God,
 a creator God;
 and then His creation
 which is part of His identity.
He does not separate Himself
 from His creation
 because He loves and enjoys it
 so much.
He is always there,
 actively involved,
 creating more color,
 more designs,
 more life,
 and more joy.
The first thing created was light.
 Of course
 it had to be light;
 for what would be the sense
 or the beauty
 of the rest of creation
 without light?
With the creative power of His word
 God says,
 "Let there be"
 and light is!
Light which
 the scientist calls
 "visible electromagnetic radiation";
 the philosopher,
 "the shadow of God";
 and the poet,
 "the smile of heaven."
God calls it "day."
 Great day!

"Let all the earth fear the LORD,
 let all the inhabitants of the world stand in awe of him!
 For he spoke, and it came to be;
 he commanded, and it stood forth."
 (Psalm 33:8-9)

בראשית ברא אלהים את השמים ואת
הארץ ...ויהי ערב ויהי בקר יום ראשון.

In the beginning God created the heaven and
the earth . . . and the evening and the morning
were the first day.

～ The First Day ～

"In the beginning God created the heavens and the earth. The earth was without form and void, and darkness was upon the face of the deep; and the Spirit of God was moving over the face of the waters.

"And God said, 'Let there be light'; and there was light. And God saw that the light was good; and God separated the light from the darkness. God called the light Day, and the darkness he called Night. And there was evening and there was morning, one day" (Genesis 1:1-5).

Words, like trucks, boats, and wagons, carry different size loads. The opening words of the book called Genesis move an overflowing cargo of meaning.

"God," Martin Buber has said, "is the most heavy-laden of all human words." Add to it other weighty words like *the beginning, created, heavens* and *earth,* and human comprehension begins to falter beneath the load.

At the same time, however, these words—and the rest of the Creation story—have about them a profound simplicity. Imponderable cosmic mysteries are uttered in words as simple as language permits.

"In the beginning God created the heavens and the earth."

Think of all this statement encompasses.

"The heavens and the earth" include some one hundred billion galaxies, each with some one hundred billion stars. Add to this the possibility of just as many planets—and the space in which those stars and planets are hung, its vastness shrinking the heavenly bodies to tiny isolated dots.

How can we comprehend such numbers, such distance? We cannot. But where finite reason fails, illustrations furnish something to grasp. Dr. Edward B. Lindaman suggests we think of our sun as being the same size as the period at the end of this sentence. Scaled down to the same degree, our sun's nearest stellar neighbor would be another dot . . . ten miles away.

In our own galaxy we have but a hundred billion stars with which to deal. But again, there is all that space. Space so vast it would take eighty thousand light years to traverse it. (Speaking of heavy-laden words, the term *light year* represents six trillion miles. Quite a weight for nine letters to bear.)

 19

Lindaman also endeavors to illustrate the distance to our nearest neighboring galaxy. Think of a scale, he says, where the earth and the sun are but a half inch apart. On such a scale this closest of galaxies would be a mere million miles away.

Continuing to "think small," we can look to the microscopic underworld of atoms and their substructures of electrons, protons, and neutrons. On this journey into *inner space* we can find other "universes" and "galaxies" dotting their own relatively vast expanses of space. And these are universes that we breathe. In and out, day and night. Someone has calculated it would require one thousand persons counting one hundred atoms a second, eight hours a day for approximately ten billion years to count the atoms on one single breath.

All this, inward and outward, and all which remains to be discovered is part of "the heavens and the earth" created by God. Has ever so much been said by so little?

Repeating the words of the Creation narrative without a quiver in the voice and a tingle in the spine seems impossible. And yet, the flames of even the most radiant words may be slowly quenched by the mists of familiarity.

My hope is that through the pictures and words of this book the ancient narrative will become new again, and we may partake of the faith, assurance, and conviction of its writer. For him, I am convinced, it was written devotionally, not scientifically, in an attitude of worship.

In this magnificent economy of words, the writer brings together temporal and eternal, creature and Creator, finite and infinite. And through it all, care is taken to show them separate from one another—although intimately related. This distinction between the infinite God and His finite creation is both key to and typical of the biblical faith.

The psalmist expresses it well:

"In ages past you laid the foundations of the earth, and made the heavens with your hands! They shall perish, but you go on forever. They will grow old, like worn-out clothing, and you will change them like a man putting on a new shirt and throwing away the old one! But you yourself never grow old. You are forever, and your years never end" (Psalm 102:25-27, TLB).

In addition to the contrast between Creator and creature, there is another between the created and the uncreated (darkness and chaos). Before God speaks there is a "formless, empty darkness." But as soon as He speaks we see an immediate response: He brings order from chaos and fullness from emptiness. The process marks its beginning with the birth of light.

Just as the new day begins with light, so does the dawn of Creation.

"And God said, 'Let there be light.' "

"Picture," says science writer Robert Jastrow, "the radiant splendor of the moment of Creation. Suddenly a world of pure energy flashes into being, light of unimaginable brilliance fills the universe."

 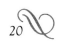

God found the light to be pleasing and good. Agreeing with that evaluation, man has also found it, to say the least, puzzling. It is one of those "the more you know the less you know" realities in God's Creation. Some of mankind's best minds have been lured to investigate light's enigmatic properties, but it is still wanting for an adequate definition.

One who attempted to define light was Isaac Newton, who from his earliest years was fascinated by its nature. After much inquiry he concluded that light was a series of particles, a conclusion which to this day can still be substantiated through the so-called photoelectric effect.

In that same period of history, however, a Dutch astronomer named Christian Huygens arrived at a much different conclusion. Light, said Huygens, is a wave phenomenon. This "interference effect" can also still be demonstrated.

These two great minds lived in the seventeenth century. The advancement of science in the twentieth century still leaves us with this duality; making both men right or, at least, half-right.

The point is, light is a puzzle. It threatens our sense of logic because there are times when it shows the characteristic of particles as Newton said, and there are times when it shows the characteristic of waves, as Huygens insisted.

God must smile now, even as He smiled when He created this puzzle. Just as you and I smile when we find a clever place to hide an Easter egg or the half of the ritual matzah at the Seder meal. Such a smile would have also been one of pleasure as God anticipated how His creatures would enjoy the light He had made. There would be no need for them to stumble and grope in cold darkness. Light would expose the darkness and illuminate the way. It would entice and tickle the eyes as the transmitter of all the beauty He would weave into the rest of His handiwork. It would warm souls as well as bodies.

His creatures would depend on light, but not just to warm them and stimulate their eyes. Light also helps us grow. One of the explanations for the increased growth of the median adult body length of three inches over the last 100 years in the United States and Europe, among other factors, is more exposure to light through recreational activities.

The dependence on light for growth of all green plants is one of the first scientific facts we learn as children because of its importance and because of the fascination of the photosynthetic process. Powered by light, all the little green factories on this earth make 150 billion tons of sugar a year, in addition to giving us human and other animal life oxygen to breathe.

In addition to growth, the *triggering* function of light is depended upon by many members of Creation. The silkworm moth is one such dependent. In spite of the thickness of its cocoon some light does penetrate, touching the "transparent" zone of the sleeping pupa. It is only when the light of longer days comes that the growth forces are set in motion and twenty-six nerve cells in the brain are activated to secrete a hormone. The tiny creature awakens, fights free of its bonds, and flies away on new wings.

For some time it was thought that seasonal changes in the coats of mammals were triggered by temperature alone. Recent discoveries, however, show that in the case of some mammals, the number of hours of light in a day calls forth the changes. In one experiment the snowshoe hare continued to wear its winter white when light was held to a winter ration of nine hours a day while a summer temperature was maintained.

So God's diverse Creation has the light it needs: to see, to grow, to guide, to trigger new phases of life. And who knows what remains to be discovered about the Creator's delightful puzzle.

As I write these words, I find myself thanking Him—for light. Yet blended with my feelings of praise there are also feelings of perplexity. And frustration. The frustration of a writer's inadequacy. I feel very much like The Man Born Blind, after his eyes were healed, in C. S. Lewis' story by the same name.

". . . Where is the light itself? You see you won't say. Nobody will say. You tell me the light is here and the light is there, and this is the light and that is the light, and yesterday you told me I was in your light, and now you say that light is a bit of yellow wire in a glass bulb hanging from the ceiling. Call that light? Is that what Milton was talking about? If you don't know what light is, why can't you say so?"[2]

We don't know what light is, but we can take pleasure in it. Even as God did. And His pleasure is not surprising. One can imagine He may have even taken time to play for awhile (perhaps a millennium or two) with His newly created light.

Can you visualize it—some time before time—before earth—God alone with His light? See Him shape it first into a giant kaleidoscope in which He views the milliard sparkling colors. Then unrolling and whipping it into space, He watches the uncountable array of colors unfurling into a spectrum-ordered, endless parade.

Rolling it up again, He hurls it out into the waiting darkness, this time allowing each individual color to create its own inimitable display. And they do. Splashing, slashing, smearing and streaking, swirling, dotting and blotching. Color shimmers and shines across the endless canvas of space.

Again He pulls the light together and shapes it into radiant beams—prismed flashes of brilliance—elongated, shining, inexhaustible. He then flings them out at 186,000 miles per second, watching them arc and return, leaving luminous boomerang paths across the endless voids.

He then forms a baker's dozen rainbows, storing them away for another day, another purpose. They take their place with attributes and byproducts of light all categorized as "later to be released": infrared, x-rays, ultraviolet, lasers, and more—still unreleased—or, at least, undiscovered.

Then, like a magician releasing a dove, He lets the light go. It spreads and radiates to an even-

ness which now makes it possible to discern its source. (As yet there is no sun.) He is the source.

As the Creator of light, He has the privilege of naming it. He calls it Day, and the darkness He calls Night.

And so ends the first day.

But the writer speaks of it in a way which rings strange to our ears: "*And there was evening and there was morning, one day.*"

Doesn't he have it backwards?

No. It is right. After darkness, there is light.

There always will be.

On the second day God created
 a firmament—an expanse
 and put the waters in their place.
The expanse was intended as a place
 for His children to breathe,
 to reach,
 to fly,
 and to expand.
He named it "heaven"!
Many are the names for water:
 rain, floods, fog,
 vapor, frost, snow,
 clouds, rivers, and oceans.
Water slakes our thirst,
 bathes our bodies
 and, when He turns it into wine,
 makes our hearts glad.

"By the word of the LORD the
 heavens were made,
 and all their host by the breath of
 his mouth.
He gathered the waters of the sea as
 in a bottle;
he put the deeps in storehouses."

(Psalm 33:6-7)

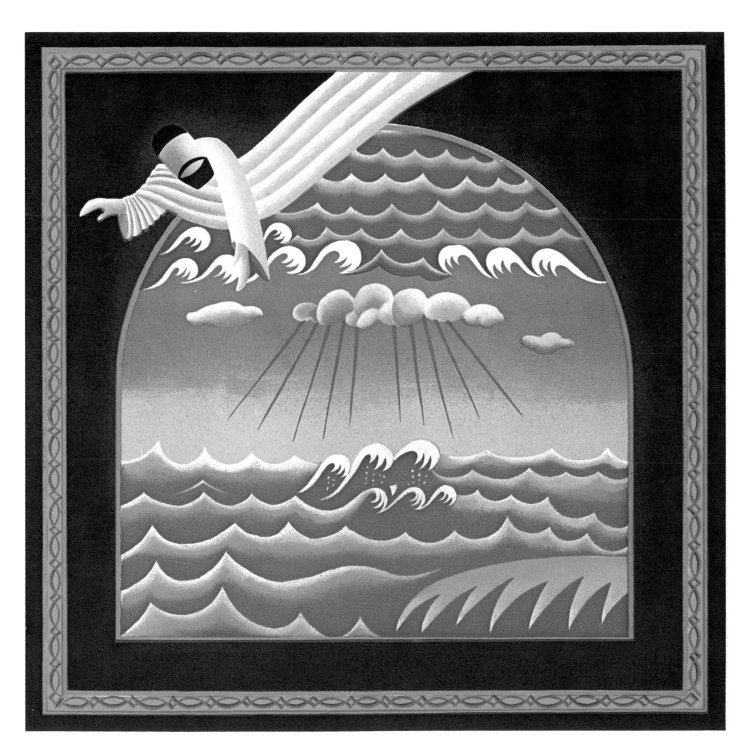

ויאמר אלהים: יהי רקיע בתוך המים,
ויהי מבדיל בין מים למים...
...ויהי ערב ויהי בקר יום שני.

And God said, Let there be a firmament in the
midst of the waters, and let it divide the waters
from the waters . . . and the evening and the
morning were the second day.

The Second Day

"And God said, 'Let there be a firmament in the midst of the waters, and let it separate the waters from the waters.' And God made the firmament and separated the waters which were under the firmament from the waters which were above the firmament. And it was so. And God called the firmament Heaven. And there was evening and there was morning, a second day" (Genesis 1:6-8).

The words cannot be spoken lightly. Simply hearing the sound of them clothes the imagination with a mantle of mystery . . . majesty.

The firmament. The deep.

Even though the darkness has been overcome with God's creation of light, He cannot continue His creative activity until He deals with a chaotic turbulence called "the deep." This term seems to describe a sort of primordial ocean, referred to in some translations simply as "the waters."

God begins to bring order to this formless liquid mass by creating "the firmament." This is the biblical writer's way of referring to that which is above his head, just as the scientist speaks of that which is above his head when he refers to the atmosphere—or space, for that matter. Both are speaking of that which they have observed.

Having fewer tools to help him in his observation, the Genesis writer refers to what is above him as "raqia," translated from the Hebrew as "firmament, expanse, vault," and "curtain." The picture it creates is one of a thin sheet "pounded out" or "stamped" as in the case of metal. Like an inverted bowl over the earth it separates or holds back the waters above the firmament from the waters below.

The image echos in other Old Testament Scriptures:

"He has stretched out the heavens like a tent" (Psalm 104:2).

"It is he who sits above the circle of the earth . . . who stretches out the heavens like a curtain, and spreads them like a tent to dwell in" (Isaiah 40:22).

The image is continued later in Genesis when rainstorms are referred to as openings of the "windows of heaven" (Genesis 7:11).

Present day scientists employ images as well. Lewis Thomas places himself on the moon gazing back at earth and its protective covering of atmosphere.

Thomas calls it *"earth's membrane."*

Like the firmament, the membrane has a "holding back" function. Before there can be life on the earth the light, created earlier, must be filtered.

Thomas writes: "Now we are protected against lethal ultraviolet rays by a narrow rim of ozone, thirty miles out. We are safe, ventilated, and incubated, provided we can avoid technologies that might fiddle with that ozone, or shift the levels of carbon dioxide.

"It is hard to feel affection for something as totally impersonal as the atmosphere, and yet there it is, as much a part and product of life as wine or bread. Taken in all, the sky is a miraculous achievement. It works, and what it is designed to accomplish is as infallible as anything in nature."

This membrane has yet another function which makes life possible for those who live beneath it. "Each day," Thomas continues, "millions of meteorites fall against the outer limits of this membrane and are burned to nothing by the friction. Without this shelter, our surface would have long since become the pounded powder of the moon. Even though our receptors are not sensitive enough to hear it, there is comfort in knowing that the sound is there overhead, like the random noise of rain on the roof at night."[3]

Praise God for the expanse which is above to protect us.

"And God called the firmament Heaven." It was thought to be His dwelling place, causing sensible and sensitive people down through the ages to look up. We are still able to attain our best by looking up. Not doing so creates the dreadful condition of spiritual round-shoulderedness.

Heinz Seelig's painting does not attempt to illustrate the firmament except to show the waters separated so there is space to live. Important in the painting is a predominance of water. One could say the same thing about the biblical Creation narrative, for where is it said that water was created? It seems to have existed before light. One cannot miss the point from either the narrative or the painting that water is of high priority and great significance in God's Creation.

Creation affirms this preeminence in countless ways. Nearly seventy percent of the earth's surface is water. As human beings, our bodies are mostly water. The very blood which flows through our veins has a plasma which is over ninety percent water. Muscle tissue is eighty percent water, as is sixty percent of our red blood cells. We are literally surrounded by liquid in the air we breathe. Estimates say the amount of water above a square mile of land on a mild summer day nears fifty thousand tons. Take away water and you take away life.

In brave, sweeping strokes, Seelig's brush reveals something more than some great stagnant pool. The variety and strength of the surging waves speak of relentless teeming power. Here is a

part of the initial chaos with which God had to deal. In addition to being separated, this raging liquid mass had to be controlled, directed, and calmed.

It would be separated into oceans, lakes, rivers, pools, streams, puddles, and drops. There would also be the less easily contained vapors, fog, steam, and clouds. Massive polar ice caps and the pervasive underground water tables would act as special storehouses for this life-supporting nectar of two parts hydrogen, one part oxygen.

Separation was the beginning of God's control of the waters. Listen to the Creator's voice as He speaks with His servant Job.

> *"Who shut in the sea with doors,*
> *when it burst forth from the womb;*
> *when I made clouds its garment,*
> *and thick darkness its swaddling band,*
> *and prescribed bounds for it,*
> *and set bars and doors,*
> *and said, 'Thus far shall you come, and*
> *no farther,*
> *and here shall your proud waves*
> *be stayed'?"* (Job 38:8-11)

Brought into submission by God's irresistible Word, the waters now yield to His commands, allowing the land to be called forth. Later His control will allow creatures to swim in the waters and find a home beneath the "proud waves." Still others will sail its breadth in tiny boats and great oceangoing vessels.

Directed by His call, the water begins its cycles: flowing, resting, evaporating, riding multi-formed clouds and then falling to earth once again as rain or snow. In this way, the Creator washes His world and its atmosphere.

The apparent simplicity of this cycle and flow of the waters belies an intricate living web of interdependent systems. The flow is not just in rivers, streams, and bodies of water; it is also channeled through nearly every created thing. Once in the ground, water is collected by the root hairs of plants by osmosis. Flowing through the plants, it evaporates out of the leaves by transpiration. Considering these facts causes one to conclude that we live in the midst of an infinitely complex plumbing system. But even more amazing than the function of this system is its supreme beauty.

Once again, it is the writer of Job who confirms God's activity here, this time as the Director.

> *"Can you lift up your voice to the clouds,*
> *that a flood of waters may cover you?*

Can you send forth lightnings, that they
 may go and say to you, 'Here we are'?
Who has put wisdom in the clouds,
 or given understanding to the mists?
Who can number the clouds by wisdom?
 Or who can tilt the waterskins of the heavens,
when the dust runs into a mass
 and the clods cleave fast together?"
(Job 38:34-38)

The calming process might be better called a *harnessing* process. For whether water serves man as a friend or threatens him as an adversary, it is a power with which to be reckoned. Water doesn't ask man's respect, it demands it.

Nature, too, must reckon with the authority of this force. Even in the tiniest amounts, water intimidates both soil and stone, cliff and canyon. Seeping slowly into hair-thin fractures, water can freeze and burst the mightiest of mountains. Serving as both creator and destroyer, it is time's helpmate. Together, time and moving water can literally change the face of our planet: smoothing what it has earlier etched, etching what it has earlier smoothed.

When teamed with cold, wind, and tides, water laughs at the thought of a harness. Like a raging giant, it has demonstrated staggering power throughout the course of history.

Case in point: the Boston Blizzard of 1978.

In the space of mere hours, the death-dealing snowstorm blasted three Boston records: the most snow in twenty-four hours (23.7 inches); the most snow in a single storm (27.1 inches); and the most snow on the ground (29 inches). Between the ferocity of the blizzard and the record high tides, more than seven thousand New England homes were either destroyed or damaged and ninety-nine people lost their lives.

Europe's North Sea has been the spawning ground for some of history's worst storms. The ultimate may have been in 1099. In that year the meteorologic juggernaut roared in from the North Sea, lashed England and Holland with unparalleled fury, and left a reported one hundred thousand deaths in its wake.

But certainly the most terrifying of water's manic displays is the phenomenon known as the tidal wave. Referred to by the Japanese as "tsunami," this dark and awesome manifestation rises from the aftermath of massive "seaquakes." Racing across the sea at speeds of 500 to 650 miles per hour, the tidal wave is only a few feet high until it begins to "stack up" in the shallows near shore. Rising like a great poised cobra, tsunami smashes the land with a rage that defies description. One estimate places the force at forty-nine tons per square yard.

For all of this, the power of water has its benevolent side, delivering incalculable benefit.

When its great rivers and falls bow to man's yoke, the resulting electricity provides the comforts for which a Solomon would have traded all his riches.

Water is a friend and a gift that bathes, sustains, and heals. It quenches the malice of hungry fires and extracts flavors from nature's products to yield the finest of brews.

And given its explosive potential, water can become the very essence of serenity. The psalmist led his sheep to the "still waters" and found there refreshment of spirit as well as body. There is a calmness stored in certain pools and streams where you and I can go and, if we tarry, we may find the tranquillity that no pill or any other elixir can produce.

It was probably at such a place, some deep and silent pool, that man glimpsed his own reflection and was given the first opportunity to behold . . . himself. Such opportunities remain to be discovered by those who are willing to search them out.

Beyond this, there are serendipitous moments when we may experience even more . . . the very presence of the One whose voice makes the raging waters still.

On the third day God
 made the dry land appear.
He formed it
 with special places
 to contain water,
 rivers and streams,
 lakes and oceans.
These He surrounded
 and bordered
 with grasses and flowers,
 bushes and trees.
He gave them all seeds
 so they could be born
 again and again
as they waltzed across the valleys
 and climbed toward the mountain tops.

"For the LORD is a great God,
 and a great King above all gods.
In his hand are the depths of the earth;
 the heights of the mountains are his also.
The sea is his, for he made it;
 for his hands formed the dry land."
 (Psalm 95:3-5)

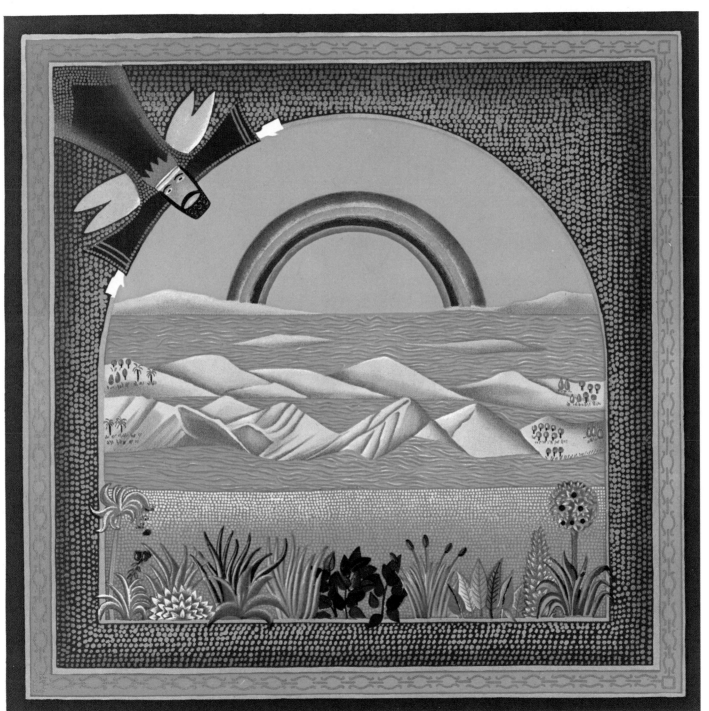

ויאמר אלהים: יקוו המים מתחת השמים
אל מקום אחד ותראה היבשה... וירא
אלהים כי טוב...
...ויהי ערב ויהי בקר יום שלישי .

And God said, Let the waters under the heaven
be gathered together unto one place, and let the
dry land appear . . . and God saw that it was good
. . . and the evening and the morning were the
third day.

~ The Third Day ~

"And God said, 'Let the waters under the heavens be gathered together into one place, and let the dry land appear.' And it was so. God called the dry land Earth, and the waters that were gathered together he called Seas. And God saw that it was good. And God said, 'Let the earth put forth vegetation, plants yielding seed, and fruit trees bearing fruit in which is their seed, each according to its kind, upon the earth.' And it was so. The earth brought forth vegetation, plants yielding seed according to their own kinds, and trees bearing fruit in which is their seed, each according to its kind. And God saw that it was good. And there was evening and there was morning, a third day" (Genesis 1:9-13).

Light clothes the earth, revealing the separation of waters by the firmament. It is the third day. When God's voice speaks again it is as if His voice is heard in the fathomless depths of the water, causing it to bubble, boil, and churn. Knifing the water's surface, sporadic protrusions appear. Steam rolls from heated stone. Rising above the surface of the water, the protrusions lift some of the water with them before allowing it to ooze and flow down slopes, along ridges, and through gullies until it finds its own level. There it settles down to rest in hollowed-out earthen bowls of various sizes and forms.

The newly appeared land now begins to dry. High peaks harden in order to stand strong thousands of feet above the ocean. The lower levels dry into crumbling rocks, packed clay, and shifting, leveling sands.

If one theory of contemporary science is correct, God's creative word was heard at the center of a much smaller earth than the one we know. Layered like an onion with an inner core of super-heated, pressure-packed iron, the planet has been slowly expanding. Some believe the earth is now twice its original size and in its expansion has opened great fissures and crevices. Water filled these massive cracks in the earth's crust, leaving the continents as we now know them.

One can easily see some of the reason behind this theory by simply examining a globe. Imagine it to be a deflating balloon. You not only see the continents coming together as it deflates, but you can also observe that they seem to fit together. Like a jigsaw puzzle.

Whatever the method of response to God's *"Let the dry land appear,"* He was pleased with the results. The men and women He would create would also be pleased, for by His hand there are places to stand. Valleys to roam. Mountains to scale. And beneath these lie hidden treasures

which will shape the course of civilization and human history. Diamonds, gold, iron, coal, and oil will take Homo sapiens to the furthest reaches of the globe.

All of this may be pleasing but surely it is not complete. There remains a sterility and barrenness to the naked land. The winds that caress the surface of the planet find no fields to bow and bend, no leaves to whisper their presence. Instead, there is only the harsh rasp of wind on ragged stone; a low and lonely moan through empty canyons and across the desolate plains.

The hillsides must be clothed, the mountains robed, and carpeting spread across the valleys.

One is reminded of the convulsive volcanic explosion of 1883 on the island of Krakatoa, near Java in the East Indies. Unleashing a force equivalent to a ten thousand megaton H-bomb, the blast literally tore the island apart, blowing six cubic miles of rock straight into the skies. It is believed that every trace of life on the island was destroyed. All that remained was a single, sullen peak, caked with pumice and ash; a terrain, visibly at least, not unlike that of the first half of Creation's third day.

What followed on Krakatoa was similar to the second half of that day when God again spoke His word, saying, *"Let the earth put forth vegetation. . . ."* And the sterile land began to take on life.

Closely studied by botanists, the island yielded only one species of life after nine months: one lonely but hopeful spider spinning his web. Three years later however, researchers found fifteen species of flowering plants and eleven species of ferns. Among the vegetation were young coconut trees, sugar cane, and delicate orchids. With the passing of a decade the island was green once again. After fifty years Krakatoa was clothed with dense forests and inhabited by hundreds of species of animals and insects. Forty-seven species of vertibrates—mostly birds and bats—were registered among the citizenry of the recently devastated island.

How could this blasted, sterile island, isolated by twenty-five miles from its nearest neighboring "live" island, come alive again? Krakatoa benefited from a process which began when God uttered His creative word. At that time, He gave plants the ability to bear seeds. Since then, fingers of green have slowly moved across the globe and wrapped themselves around our earth, perpetuating and replacing life.

This movement is dependent upon seeds of infinite shapes, sizes, and weights. They vary from the microscopic mustard seed (which is really quite large compared to some) all the way to the sturdy coconut. Some seeds are so light the slightest breeze can loft them away from their moorings. In the case of spore-type seeds, however, the wind has only to catch them as their plants magically launch them into the air.

Those seeds which cannot be propelled so easily have to depend on birds to eat them and carry them as passengers in the birds' digestive tracts. This is how the island of Krakatoa was resur-

rected. As for the coconuts, they probably floated in, as did some of the smaller seeds. Still others probably clung to the coats of small animals who floated on pieces of debris to their new island home. For all of them, it was merely one twenty-five mile leg of an around-the-world journey.

When God called for seed-bearing vegetation He put into force a cooperative effort for all of nature. Man, too, has played a role in the process, for in his wanderings he has unknowingly carried seeds throughout the world. He has also knowingly introduced alien seeds to new continents—and then convinced himself the plants were native. "Kentucky" bluegrass, "Colombian" coffee, and "Washington" apples carry adopted New World names, although they emigrated from the Old.

Seeds still travel in and travel on host animals all over the world. They fly with the wind and float upon the waters. Still more of them enter the soil in a most deliberate way via the supermarket and seed catalogs, allowing us to have a mindful and planned part in God's creative activity. It may be in the small rooftop garden of a great skyscraper, in the window box of a crowded tenement, in Grandma's back yard garden patch, or in the proud, endless wheat fields of the world's great plains. Wherever seeds explode into vegetation, it is all a part of the process which God started when He said, *"Let there be plants yielding seeds."* Long may the process continue.

Seeds bear yet another message to all who would listen: The Creator is a God of *extravagance.* When we ponder the stars in the heavens or the depths of the seas we are prone to ask if there really needs to be that many stars or that much water.

This same extravagance carries over into plant life. Grasp a mere pinch of earth and hold it between your finger and thumb. Look very closely at that bit of earth and you may observe tiny root hairs. If they belong to what was once a single grass seed that has been growing in the soil for at least four months, the length of those root hairs will total about six thousand miles per square inch.

Extravagant?

Go to the forest and witness it again. See the lake covered with a blanket of pollen from the pine tree. It would take eternity to count those miniscule yellow beads.

It may take less time to count the leaves on one of the trees there in the forest. Nevertheless, it is easier to accept the estimate of an expert who tells us that the number of leaves a large elm tree can make in a single season exceeds six million.

As we have said, God displays this same extravagance with seeds. Predominantly a practical person, I prefer the peach approach: one piece of fruit, one seed. So I am just a little amazed when I slice a cantalope or bite into a tomato. Both seem to have enough seeds to conquer the world and extend their posterity forever. But even these are humbled by the orchid. A single orchid bloom produces over a million seeds.

Water, stars, sand, leaves, seeds—millions and millions and millions. Such an extravagant God! It really is not so surprising, though, once you have experienced the extravagance of His love.

There is, however, what might be called a balance to this divine extravagance. When you look closely at the plant kingdom you also see evidence of divine practicability. It shows itself in the ingenious fact that so many of the packages in which the seeds are naturally packed are delightfully edible. Because of their mouthwatering edibility, we are lured to be aids in the disbursement of these seeds.

When I was a boy I enjoyed hiking in the mountains of Colorado. On one such excursion I rounded a bend in the trail and came upon, of all things, a peach tree. Delighted, my first audible question to whoever might be listening was, "Well, how did that get there?"

The tree grew near an old railroad bed, part of a long-abandoned line that used to carry the gold from Cripple Creek to Colorado Springs.

As I hiked on down the trail I tried to reconstruct in my mind's eye how that fruit tree took root in the Colorado high country. I could see an engineer, leaving home early one morning with a lunch pail under his arm. My mental camera then switched to the next scene—later that same day. I could see the engine straining and puffing up the hill. In the window of the locomotive, the engineer digs into his lunch pail and pulls out a plump, juicy peach. He raises it to his mouth and indulges until there is nothing left but a well-scavenged seed which he simply tosses from his window. The peach pit bounces down the hill, hitting the ground a few times before it finally comes to rest . . . in the very spot where a young hiker would meet a full-grown peach tree, years later.

For the rest of the day I looked for more peach trees. There were none. Had that engineer been the only person to have ever thrown a peach pit from that twice-daily train? Probably not. Out of all the tourists and miners who rode the passenger cars over the years surely a number jettisoned peach pits from the windows. But the odds are pretty long that the conditions will be right for one stray peach pit to take root in the Rockies. (Perhaps those "packages" of nature with the extravagant number of seeds aren't such a bad idea after all.)

I still wonder about that engineer. Did he know when that peach enticed him with her beauty, her taste, and her promise of refreshment that he was being lured into a process developed for the propagation of peach trees? Very practical.

This extravagant, practical Creator is also very aesthetic. His artistic touch makes it difficult for us to believe that those green trees and plants which enthrall us with their beauty are actually *factories*. When you realize what a blight man-made factories create on earth's green landscape, God's versions seem that much more remarkable. Man's factories excrete and belch pollution

into our rivers and atmosphere. The antithesis of anything aesthetic, they stand like monstrous monoliths, webbed by countless strands of corroded pipe.

Not so with God's green factories. These produce those priceless, life-bearing commodities of energy and oxygen. And their beauty in no way hinders their efficiency. Employing the miraculous process of photosynthesis, the green factories dwarf the industrial production of our civilization. While the world's steel mills are turning out 350 million tons a year and the world's cement factories yield 325 million tons of cement, the green world produces, not millions, but *billions*— 150 billion tons of sugar each year.

It is interesting that so many of our factories use water just like God's. In the summertime a good tree heaves a ton of water a day through its multicelled structure. More interesting is the fact that when we want to beautify a piece of land, we plant trees. They always do their job well. Especially when they grow high enough to hide the man-made factories.

In what are called the liturgical colors, the color green always represents life. The choice is a good one. Whether we realize it or not, when we ponder the "lazy green landscape" we are looking at something which teems and brims over with life. Victimized by time, our human eyes miss the delightful animation of this lively, living community.

If only we had time-lapse eyes and could see what goes on in the green world over a period of days squeezed down into just a few minutes. We would see the dancing and twisting of tiny flowers and towering trees as they daily follow the sun across the sky. Vines climbing like monkeys, seed pods exploding, branches waving, leaves changing, grass expanding, blossoms opening and closing as all of the colors polychromatically change like a great silk curtain blowing in the wind.

Absolutely nothing is still. So we clap our hands and shout with an empirical assurance, "It's alive, it's alive, it's alive!"

Oh yes. In the third picture of the Creation some folks say they can see a rainbow in the background. If *you* see one, count it as grace. Which is what all rainbows are.

On the fourth day God
 decorated the firmament.
Sun for the daytime.
 Moon and stars for the night.
For the poet they are
 God's mystical jewels.
For the navigator—
 The way home.
And for the farmer—
 Clocks and calendars.
For all of us they are
 constant reminders of His caring presence.

"Lift up your eyes on high and see:
 who created these?
He who brings out their host by number,
 calling them all by name;
by the greatness of his might,
 and because he is strong in power
 not one is missing."
 (Isaiah 40:26)

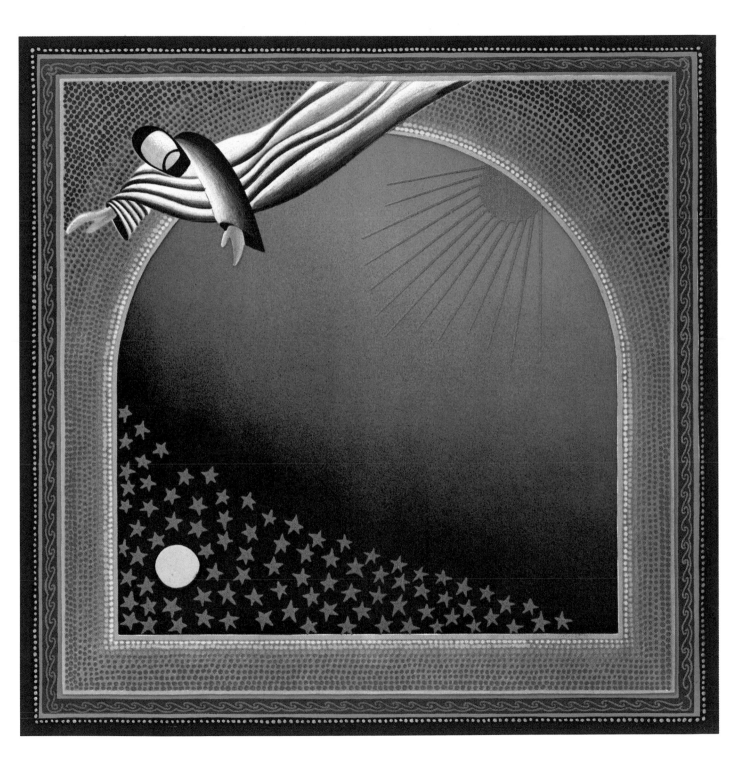

ויאמר אלהים: יהי מאורות ברקיע
השמים להבדיל בין היום ובין הלילה...
...ויהי ערב ויהי בקר יום רביעי.

And God said, Let there be lights in the
firmament of the heaven to divide the day from
the night . . . and the evening and the morning
were the fourth day.

~ The Fourth Day ~

"And God said, 'Let there be lights in the firmament of the heavens to separate the day from the night; and let them be for signs and for seasons and for days and years, and let them be lights in the firmament of the heavens to give light upon the earth.' And it was so. And God made the two great lights, the greater light to rule the day, and the lesser light to rule the night; he made the stars also. And God set them in the firmament of the heavens to give light upon the earth, to rule over the day and over the night, and to separate the light from the darkness. And God saw that it was good. And there was evening and there was morning, a fourth day" (Genesis 1:14-19).

It was the middle of the week and God decided to work at home.

On this day He would finish His work in the heavens by creating containers for all of the light which He called forth on the first day. These containers would be as numerous as the sands on the seashore. Because of their close proximity, two of them would have special significance to the earth.

Appearing greater and brighter than anything else in the heavens, the one called "Sun" would rule the day. The pale one, "Moon," would rule the night. These two, along with the stars, were a great distance away. But it was soon discovered by earth's inhabitants that these lights not only ruled life upon the planet, they were key to the very existence of life.

The necessity and awesomeness of these heavenly bodies has caused much of civilization to worship them. Many of the early civilizations had sun gods and moon gods, and to this day our planets carry names of gods from these civilizations.

In spite of the document's age, it is significant that the Genesis account carefully avoids ascribing any divine attributes to the heavenly bodies. Nor does it in any way confuse the Creator with that which He created. Genesis makes it clear that it is God who creates the sun, moon, and stars. And it is He who empowers them, commissions them to their purposes, and sets them in motion on the courses they are to travel. Yet through it all, He remains distinct and separate from all His hands have formed.

These heavenly bodies, as with all of creation, are as dependent on God as we are on them. As an urban people, however, we have lost the sense of our dependence on these spatial spheres—even though we are a people dependent on power. During these last years we have either experi-

enced or read about the nightmare of urban blackouts caused by the blowing of a city's power source. Devastating as these may be, the limited electrical blackouts do not provide even a faint clue as to what would happen if our planet's power source, the sun, should suddenly flicker and fade to black.

Not only would the "green factories" shut down, but every inhabitant of earth would freeze in a nightmare of darkness—if we didn't first of all die for lack of oxygen.

We need not, however, contemplate such a catastrophe. Not for awhile, anyway. Scientists tell us that the sun will not burn out for another five billion years. What an awesome stockpile of energy!

The numbers describing it are all beyond comprehension. We are told that the temperature of the sun's core reaches fifteen million degrees centigrade. Some sense of how hot this really is has been illustrated by British astronomer James Jeans. If we took a piece of matter from the core of the sun and put it on the earth, Jeans says, it would kill a person as far as ninety-four miles away.

The amount of energy we use here on earth is negligible compared to the sun's expenditures. It sends out more energy in three days than modern civilization would create if it burned in one moment all the wood, coal, gas, and oil stored here in our earth.

What a delicate task God performed when He placed in His heavens this massive ball of energy with a diameter 109 times that of earth. Putting it too close would have turned earth into a rotating hell. Too far would have turned our planet into a great spinning snowball. At its present distance—which seems to be just right—it can make an energy delivery in a little less than eight and a half minutes. This is in conjunction with its myriad other chores: purifying water and air, feeding oceans and forests, melting snow and ice, building clouds, directing winds, creating fuel, budding blossoms, sustaining life, regulating tides, and establishing seasons. Not to mention illuminating the whole earth.

William A. Shurcliff has put some numbers with these chores:

"The sun grows $100 billion worth of wheat, corn, etc., each year; grows 5 trillion trees and shrubs, 17 trillion flowers; provides daytime illumination for 200 million (?) people; melts 10 trillion tons of snow and ice each spring; vaporizes 6 trillion tons of water that result in rainfall supplying 3 million acres of farmland, 1,000 rivers, warms 5 trillion tons of coastal water in which 10 million people swim; produces winds that drive 100,000 windmills, propel 700,000 sailboats, lift 200,000 kites, dry 1 billion freshly laundered sheets, and purge smelly air from 1 million city streets."[4]

Accomplishing all of the above tasks could hardly be called "work" for our sun. This God-given giant has energy man has not yet *begun* to tap. It seems ironic that anything as obvious as the sun (what could be more obvious?) would be so overlooked by most of humanity in our search

for energy. There is no energy shortage. If we chose to spend as much money in researching how to tap the sun's energy as we do probing the ground, we would find ourselves with a much happier problem; that of what to do with the excess.

The sun, with the moon and stars, has additional assignments from the Creator; "for signs, for seasons, for days and for years." As urbanized persons we are apt to slip past these words. Rather than looking to the heavens for our weather forecasts, we look to the media. As far as seasons are concerned, they are of little import except perhaps in choosing our next sports activity. But even then, with snow machines and indoor swimming pools, the seasons seem to make less difference. And the proliferation of calendars and timepieces make looking to the sky for such things, at best, a novelty.

This has not always been the case. For our ancestors, knowledge of what the sky was saying was a matter of life and death. The hunters knew that there was a relationship between the migrations of the animals and the placement of the sun in the sky. The days could be scored by observing the shape of the moon. Planting time and harvest were determined by the sun's path.

Our forebears had good reason to look to the heavens. And who knows all that they gained? When you read of the things they saw you wonder if they were not a lot healthier and less stressful than us. The pure relaxation of reclining on a hillside on a warm summer night is an experience some of us have never had, and many more of us have forgotten. There is a peace that comes as one considers the stars and begins to see in their wondrous depths what our ancestors saw. They may have been Americans, who saw a Big Dipper. Or Greeks, who saw in the same constellation a Great Bear. The Chinese saw the Celestial Bureaucrat and the English beheld the Plough. Early Europeans spoke of Charles' Wagon.

They're all there—Dipper, Bear, and Bureaucrat. And many more as well, if we would just take time to look.

Whereas all of nature seems tuned in with the sun, the moon also has its realm of dependent creatures. There is a whole world of sea-dwellers, especially those who dwell at the edge of the sea, whose life is directed by the moon. Grunion, horseshoe crabs, and palola worms are among the more famous of the lunar-clock species—those who do not wait for the tides, but anticipate them.

The gentle-appearing moon is also a source of power: the staggering might of tidal power. Can it be harnessed? Experiments in putting tidal power to work for man's benefit have gone on for hundreds of years. The United States had its first tide mills in the Boston area back in the 1630s. As other sources of energy became available, however, this "moon power" was allowed to slip into obscurity. But in today's energy-hungry world, tide plants are again being built. The Republic of China presently leads the way in tidal power, employing, according to recent reports, forty tidal plants with eighty-eight more under construction.

God has favored us with abundant resources we could begin to make use of rather than expect terra firma to provide all of our energy.

Realizing that the moon-powered tides could be providing countless megawatts of electricity, I still find it difficult to speak of the moon in such a coldly utilitarian way.

I felt the same way on the historic day the astronauts landed on the moon. Scooting up close to the television, I strained my ears to hear Neil Armstrong's description of the moonscape.

"It's gray and it's very white chalky gray, as you look into the zero phase line, and it's considerably darker gray, more like the ashen gray as you look up ninety degrees to the sun. Some of the surface rocks are in close here, that have been fractured or disturbed by the rocket engine plume, are coated with this light gray on the outside, but when they've been broken they display a dark, very dark gray interior and it looks like it could be country basalt."

Summation: It is gray.

I couldn't believe it. Was this the same moon I'd grown up with . . . this . . . dry, dusty bowling ball? If I didn't do something quickly, NASA's dead gray orb was going to crush the moon of my emotions and imagination. That pale, romantic moon—the one that rhymes with spoon and June—would be destroyed forever.

The Apollo program could have been disastrous for my well-being had I not determined that for me there would always be *two moons*. I could grant the scientists their own moon—that chalky, airless landing pad with a gravitational field to tug at earth's tides. They could have that one, and were welcome to it. But there would be another moon for me . . . a moon capable of moving emotions and melting hearts. This latter moon would provide extra light for the harvest. For lovers, it would provide less light—and yet, just enough. This moon would change white snow to silver and throw a luminous path all the way across the ocean. Dancing in the pools at the ocean's edge, its mischievous beams would dart away now and again to ignite the fringe of the surf with fluorescent beauty.

This moon would be made of cheese and have a man in it.

What I am trying to say is that I have found the moon to be inspiring. I do not want to lose that inspiration. Even though I "know" that earth's great satellite casts a heatless light, I do not want to be told that I have never felt its warmth. Life can be gray enough without adding a gray moon.

Could it be that one of the reasons God made the moon was to *inspire* His people? I think so. And the sun and the stars as well. The psalmist was inspired by the sun which he saw as fulfilled, strong, and joyful.

> "In them he has set a tent for the sun,
> which comes forth like a bridegroom
> leaving his chamber,

and like a strong man runs its course
with joy.
Its rising is from the end of the heavens,
and its circuit to the end of them;
and there is nothing hid from its heat."
(Psalm 19:4-6)

The writer of Job, too, caught the vision and wrote of the time "when the morning stars sang together, and all the sons of God shouted for joy" (Job 38:7).

It is a picture that cannot be forgotten: the very stars of the heavens singing for the sons of God, who, in turn, cheer them on with cries of sheer joy. The text does not say what they were singing and shouting about, but I would not be surprised if it was about the moon as it spun one of its nightly spectaculars.

Now obviously, there cannot be two moons.

There is just one, and it is cratered, dark, and gray. But that is not the way it appears to us. Our eyes gaze upon a thing of consummate beauty. A radiance that borders on glory. And yet the glory belongs to another, for the moon catches and reflects the light of the sun. When I see it, I am reminded that even my gray life displays its own God-given radiance when it reflects the light of His love.

 47

On the fifth day God spoke
 And creatures appeared.
Feathered and winged ones
 Soared through the air.
Scaly and finned ones
 Swam through the sea.
God liked what He saw,
 He called for more.
 Be fruitful and multiply, He said
 With my blessing.

"O LORD, how manifold are thy works!
In wisdom hast thou made them all;
the earth is full of thy creatures."

<div align="right">(Psalm 104:24)</div>

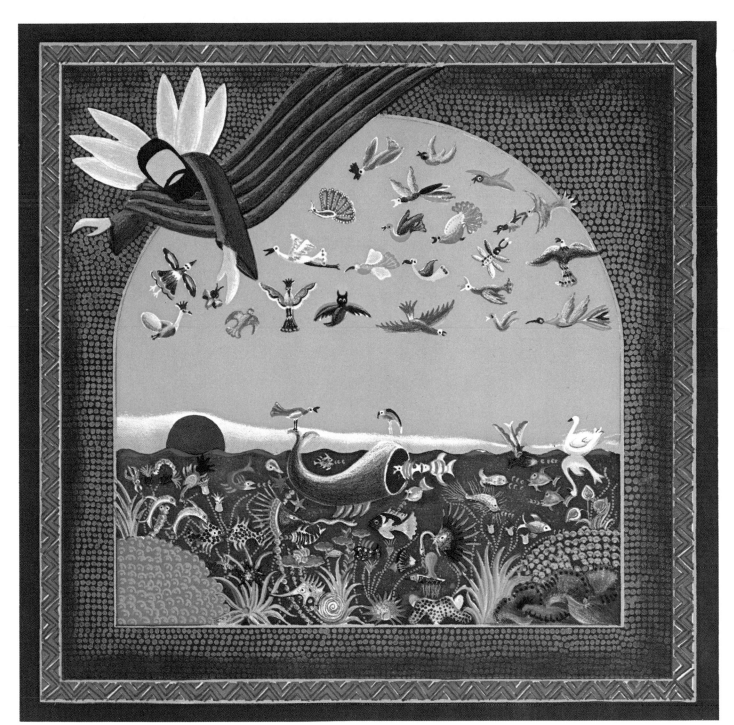

ויאמר אלהים : ישרצו המים שרץ נפש
חיה ועוף יעופף על הארץ...
...ויהי ערב ויהי בקר יום חמישי .

And God said, Let the waters bring forth
abundantly the moving creature that hath life,
and fowl that may fly above the earth . . . and
the evening and the morning were the fifth day.

The Fifth Day

"And God said, 'Let the waters bring forth swarms of living creatures, and let birds fly above the earth across the firmament of the heavens.' So God created the great sea monsters and every living creature that moves, with which the waters swarm, according to their kinds, and every winged bird according to its kind. And God saw that it was good. And God blessed them, saying, 'Be fruitful and multiply and fill the waters in the seas, and let birds multiply on the earth.' And there was evening and there was morning, a fifth day" (Genesis 1:20-23).

On the fifth day God came down to earth.

In the heavens everything was in place. The earth, now completely furnished with everything which supports life, was ready for some tenants.

Realizing this, God spoke His creative word and millions of creatures of every shape, size, and color appeared deep in the waters, high in the heavens, and across the face of the earth.

"Life" was upon the earth before, but the life of the fifth day was unique because it was not rooted. The writer refers to it as "living and moving." Here were creatures able to fly, walk, run, swim, gallop, crawl, hop, jump, slither, swing, and burrow.

The word "birds" in the English text refers to a word which has a broader meaning in Hebrew. It probably means all living things that fly—everything from winged insects to bats. The other "movers" and "livers" are fish in the waters and inhabiters of the land which include cattle, creeping things, and beasts. These latter three were created on the following (sixth) day, but we will place them here—together with the rest of the "living creatures that move," in the general category of animals.

Again, we are overwhelmed by God's extravagance. Animals come in a million species, more than fifty thousand of which are species of fish. The bird family boasts of between eight thousand and nine thousand species. And when you begin to look at individual animals within each species, the numbers take on cosmic proportions. Locusts, for instance, must be measured by the swarm—some up to fifty kilometers in width.

But even these numbers are miniscule in comparison with the number of eggs laid by these living movers. In one summer season a fly and its offspring lay 191×10^{10} eggs. A carp lays about

three hundred thousand per year while a queen bee lays more than two thousand eggs a day during the summer season for a number of years.

These numbers are so boundless that they become meaningless in our finite minds. And yet, it is important to note that this is not the work of some uncontrolled, helter-skelter, Creator-God-gone-amuck. There is a control and balance within His extravagance which keeps all things within manageable quotas.

This check and balance is illustrated in the often-quoted story about Great Britain's old maids being the key to the strength of the British Navy in an earlier era. The "logic" of the story goes like this. Old maids were the owners and protectors of cats throughout all of England. The cats dutifully and gluttonously kept the population of mice down to a very small number. This allowed for an increase in bumblebee nests, the combs and larvae of which the mice would have eaten had they themselves not been eaten by the cats. More bumblebee nests meant more bumblebees who, being the only insects with a long enough tongue to pollinate red clover, did just that. This contributed to the great success of red clover in England. Red clover was the staple diet of British cattle which, as "bully beef," was the staple diet of the British Navy. So . . . Britannia ruled the waves because of her many spinsters who fortunately loved cats.

Simplistic? Yes. But certainly a graphic clue to the balance which keeps nature's abundance from getting out of hand.

This story also suggests the usefulness of each living thing in God's creation. (There is a sense in which cats and bumblebees can also be credited for the strength of the British Navy.) The presence and use of animals benefit humankind in many ways. Not only do they provide food and drink, but they have clothed us and transported us. We have been guarded and protected by animals. We have been comforted by their companionship when other friends seemed distant and few. And who can say how many lives have been saved by the likes of little canaries which are employed to warn coal miners of deadly gases—or by seeing-eye dogs that guide the blind.

Humans continue to find new uses for animals. Ranches are being established in Argentina to raise capybara, the world's largest rodent. The meat of the capybara is being hailed as a nutritious, inexpensive alternative to beef. Digesting food three and a half times more efficiently than cattle, the capybara produces six times as many offspring in a given year.

In Nigeria, the giant African land snail is being farmed to create yet another affordable meat source. Pound per pound, the snail meat yields as much protein as beef. And they are fast-growers, weighing up to half a pound each.

The ya-ez is being raised in Israel's northern Negev. A cross between the Sinai desert goat and the ibex, the ya-ez can endure extreme climates and produce tasty meats.

For all of this, God seemed to have still other purposes in mind when He created animals.

There is a Jewish tradition coming from the Rabbis that the animals were given to teach us.

"Animals were not created merely to serve man and contribute to his comfort, for God intends to teach through the creatures of the field and make us wise through the birds of the sky. He endowed many animals with moral qualities that they might become a pattern for man. If the Torah was not given to us, we could have learned honesty from the ant, that never takes from another's store. We could have learned modesty from the cat, who is careful to wash herself. By observing the grasshopper we could learn a zeal for life, for she sings till the moment of death. The rooster teaches us good manners for it first coaxes, then mates. The stork conveys a double lesson. He guards the purity of his family and is compassionate and merciful towards his fellows. Had we but observed the animals, we might have learned to be gentler men."[5]

This story is part of a tradition that places high value on animals and great concern on how they are treated. And it further suggests that our sensitivity to one another may be in proportion to the care we reflect in our treatment of animals. One scholar warns, "The boy who, in crude joy, finds delight in the convulsions of an injured beetle or the anxiety of a suffering animal will soon also be dumb to human pain."

An old story says that Moses was chosen to lead his people because of his tenderness toward animals. It says that while he was tending the flock of his father-in-law, Jethro, one kid ran away. Moses, after searching, found it near a pool of water where it was drinking.

Approaching it he said, "I did not know you ran away because you were thirsty. Now you must be weary." He then lifted the kid to his shoulders and carried it back.

God was pleased and told Moses, "Because you showed mercy in leading the flock of a mortal, you will surely show mercy in tending My flock, Israel."

In this mood God asks tenderness and mercy toward His animal creation. "If you chance to come upon a bird's nest, in any tree or on the ground, with young ones or eggs and the mother sitting upon the young or upon the eggs, you shall not take the mother with the young; you shall let the mother go, but the young you may take to yourself; that it may go well with you, and that you may live long" (Deuteronomy 22:6).

This passage of scripture is often considered with Leviticus 22:28 which says, "And whether the mother is a cow or a ewe, you shall not kill both her and her young in one day." The rabbinical explanation for such laws has to do with empathy and caring. It reflects concern that the young not be slain in the sight of the mother. Believing that animals suffer grief as well as humans, the Rabbis say the mother should not have to see the slaughtering of her young.

In addition to tenderness and mercy, God also requires a kind of justice and fairness for animals. In this spirit the Bible requires that the ox which treads the grain shall not be muzzled, and that beasts have the right to rest on the Sabbath just as humans do.

When God speaks to Job, we learn something else about His relationship to the animal kingdom. In asking Job if he has the same abilities with the sea monster as his Maker does, God reveals His own relationship with this great animal. *He plays with it.* Job chapter 41 makes it clear that God takes great joy in this creature He has made.

You can almost feel God's joy and justifiable pride as you study Heinz Seelig's paintings—especially those of creation's latter three days. They inspire you to fantasize what exhilarating days the fifth and sixth days must have been. On the previous days it had been relatively quiet around the planet. Nothing much to hear but the whisper of breezes, the gurgling of streams, and the slapping of waves. But with all of these animals came a great joyful noise that must have sounded like a resounding hymn to the Creator. The busy buzzing of bees, the chirp, chirp, chirping of chicks, and the hollow howl of hounds.

Lions roaring, peacocks screaming, cats meowing, frogs croaking, birds warbling, whales humming, donkeys braying . . . what a joy for their Maker!

I am sure He planned to create humankind all along, but if there was ever any doubt in His mind, this was the day that cinched it. Now He simply *had* to create humans. He wanted someone to whom He could show these delightful animals—someone who could enjoy His creation with Him. He would certainly want us there to watch the rhythmic flow of muscle as a cheetah sped across the plains. He would be sure to call our attention to the sure-footed gait of the mountain goat as it scampered up a rocky mountain slope. With a chuckle, He would wait for our reaction when we spotted the platypus with its duck bill, webbed feet, and otter fur. Enjoying our perplexity, He would deepen the riddle by informing us that the creature lays eggs and then secretes milk to nurse its hatchlings.

He would invite us to tarry with Him to watch a living drama in the metamorphosis of a caterpillar into a moth.

He would schedule a few home tours for us, pointing out the skillful engineering of the beaver dam and the custom air conditioning of a termite's nest. He would explain how the weaver birds lay their eggs in the one hundred or so apartments in the large communal nests which they build.

He would want us to see one of His giant whales, lounging in the deeps, and watch our expression as that seemingly immovable mountain of flesh suddenly leaped twenty feet into the air.

There are so many little things He would share. Like the hummingbird's uncanny ability to hover and fly backwards. Like the chameleon and its color-changing disguises.

I could go on like this but such fantasies are really unnecessary. For it is He who placed us among His creatures for three-score and ten years to see it all. It is quite literally the greatest show on earth, and it is free.

But there is a problem. Some of the best acts have been eliminated. At the time when the thir-

teen colonies were being established over 60 million buffalo grazed the wild grasslands of North America. By 1893 there were only 1,090 left. What was the great plague that destroyed the buffalo?

Human beings. Mostly of the male variety.

The giant tortoises of the Galapagos Islands, which at one time numbered 250 thousand, are now down to a mere 6 thousand. Hundreds of other animals join the vanishing tortoises on the endangered species list. Certainly, the Creator must be grieved.

God's own attitude toward His living creatures is magnificently displayed in Psalm 104—often called "The Creation Psalm." The emphasis of the psalmist throughout is that God *cares* for His creation. In fact, much of what He creates is because He does care. He creates springs so the beasts can drink, He creates trees with branches for the birds to have their habitation, and He creates grass for the cattle to graze contentedly through the long afternoons.

He cares.

And His desire is that we care, too.

The sixth day was a big day
 and a wrap-up.
First God created cattle
 and creeping things and beasts.
Finally, He created human beings
 as male and female.
He gave them
 an earth to rule
 and fruits and vegetables to eat.
Best of all,
 He gave them His likeness
 so He could be seen in them
 and so they could relate to Him
 as only "likes" can.

"O give thanks to the God of heaven,
 for his steadfast love endures for ever."
 (Psalm 136:26)

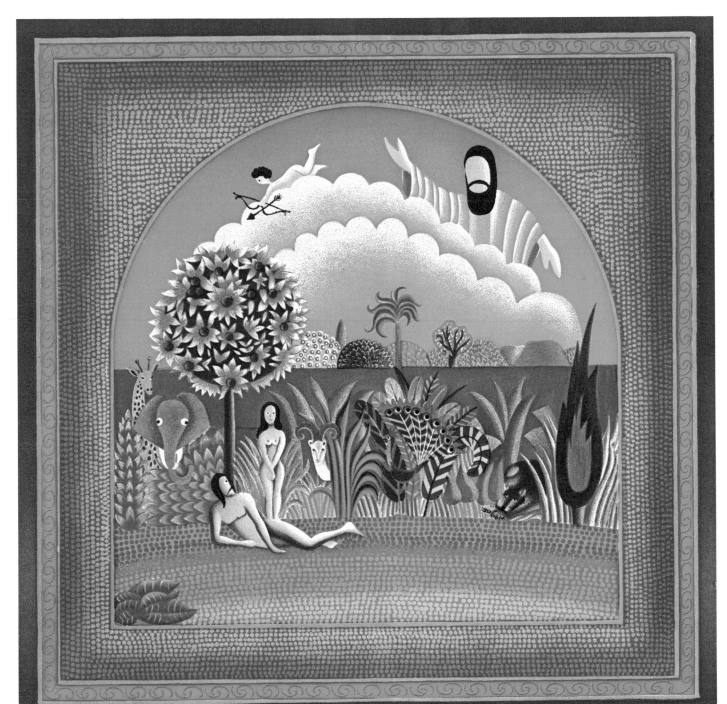

ויאמר אלהים : נעשה אדם בצלמנו
וכדמותנו ...ויברא אלהים את האדם
בצלמו, בצלם אלהים ברא אתו, זכר
ונקבה ברא אותם...
...ויהי ערב ויהי בקר יום שישי.

And God said, Let us make man in our image,
after our likeness. So God created man in his
own image, in the image of God created He him;
male and female created He them . . . and the
evening and the morning were the sixth day.

The Sixth Day

"And God said, 'Let the earth bring forth living creatures according to their kinds: cattle and creeping things and beasts of the earth according to their kinds.' And it was so. And God made the beasts of the earth according to their kinds and the cattle according to their kinds, and everything that creeps upon the ground according to its kind. And God saw that it was good.

"Then God said, 'Let us make man in our image, after our likeness; and let them have dominion over the fish of the sea, and over the birds of the air, and over the cattle, and over all the earth, and over every creeping thing that creeps upon the earth.' So God created man in his own image, in the image of God he created him; male and female he created them. And God blessed them, and God said to them, 'Be fruitful and multiply, and fill the earth and subdue it; and have dominion over the fish of the sea and over the birds of the air and over every living thing that moves upon the earth.' And God said, 'Behold, I have given you every plant yielding seed which is upon the face of all the earth, and every tree with seed in its fruit; you shall have them for food. And to every beast of the earth, and to every bird of the air, and to everything that creeps on the earth, everything that has the breath of life, I have given every green plant for food.' And it was so. And God saw everything that he had made, and behold, it was very good. And there was evening and there was morning, a sixth day" (Genesis 1:24-31).

Since the first day of creation, there has been a sense of building and progress. It is now the sixth day and a feeling clings to the air, hugs the horizon, shimmers in the first morning light.

Anticipation. A hushed expectancy.

The sixth day will be a climactic day, the grand finale of the Creator's majestic, living symphony.

Early in the day God speaks, calling forth cattle, creeping things, and beasts of the earth according to their kinds.

God has yet one more creative act, but this time He does not speak His customary "Let there be. . . ." He does speak, but somehow His words seem to be directed to someone else.

"Let us . . ." says the Creator.

To whom does He speak? Who is this other person or persons? Why the use of the plural? In the original Hebrew, that word for God, *Elohim*, is in the plural form. And yet scholars are not agreed as to why God says "us." Some suggest He is addressing His angels and go on to cite numerous and divergent explanations for where the angels come from.

Others say that the plural form indicates "royalty and majesty." Certainly this would be appropriate in referring to the great King.

Various Christian theologians say that the "us" refers to the three Persons of the Trinity: Father, Son, and Holy Spirit. There is even a philosophical explanation which asserts that since

God is by nature self-giving, it is necessary to have someone to whom He can *give* Himself in order to *be* Himself. Therefore, He must be an "Us."

The reader may make his or her own choice, but whatever the plural may mean, it at least affirms God's uniqueness and holiness.

After sharing His plan, God follows through and creates "man" in His own image as male and female. From this moment forward Creation becomes very personal for us, because it becomes our story. Woven into the very fabric of this sixth day is the answer to our eternal question: "Who am I?"

The psalmist asserts, "I am fearfully and wonderfully made." This we can be assured of because God is our Maker. In the creative world in which we live, created things derive value from their creator. A Picasso painting may be pleasing to the eye, but its value increases when we are told it is a Picasso. In the same sense, our deep and abiding value comes from the fact that we are created by the Lord God. The contemporary poster maker is more right than educated when he or she writes, "God don't make no junk."

The Creator's masterpiece is nothing less than a wonder.

A study of this human creature is an awesome experience. Typically, humans take their own bodies for granted—until something malfunctions. When that happens, we are alerted to consider the overwhelming intricacy of this two-armed, two-legged, self-powering mechanism of bone, muscle, and plumbing. A lingering danger in our present society is to think of man as little more than a body. And yet this intricate, finely-tuned machine is equipped to think. All that our civilization knows under the heading of progress was first conceived in the human brain. Although those living centuries later may call us primitive, the achievements of human thinking to date stretch the imagination to its limits.

We Are Made in God's Image

All living creatures may lay claim to the value of being made by God. Human beings are highly developed mammals who were created on the same day as other animals. And yet, as humans, we possess an infinite "otherness" that separates us from our fellow living creatures: We are created in the image of God.

Different theologians interpret the meaning of "image" in different ways. In general, however, they seem to be saying that there are attributes which God and human beings possess in common, but which animals do not possess. These shared attributes are what it means to be "in His image." Major among these is the ability to reason. In addition, we are unique in having culture, science, and art. And we have consciences, whereas the animals, at best, have a fear of punishment. Summarizing, most would say that being in the image of God makes us intellectual, moral, and cultured.

We Are Spiritual Beings

If we were to stop with the intellectual, however, we would miss what is most significant if we are going to live up to the image of God within us and become all we were intended to be. In contrast to the rest of God's handiwork, humans were created as spiritual beings. We are the ones who can pray to God—converse with Him—because we are in His likeness. We can live in relationship with Him. Heinz Seelig's painting of this day reveals a significant change from the portrayals of previous days: God Himself has moved into the picture. Seelig's representation of the Creator's personal presence illustrates the relational involvement we can have with Him when we exercise the response of faith.

There is an intimacy, a fellowship, a dialogue, a reciprocity. Yes, even of faith. God asks us to believe in Him because He believes in us. Faith involves risk and God took a profound risk when He set us free upon this earth with the choice of accepting or rejecting Him and His way. Our faith, then, is in response to His faith. Our love to His love. I love Him because He first loved me. Robert Bridges, an English poet who lived at the turn of the century, affirms this truth.

> "In truth, 'spiritual animal' is a term for man nearer than 'rational' to define his genius. Faith being the humanizer of his brutal passions, the clarifier of folly and medicine of care, the clue of reality, and the driving motive of that self-knowledge which teaches the ethic of life."[6]

I take the ethic of life to be love.

We Are Creative Beings

After watching God create for six days we could reasonably conclude that He is creative. Being in His image would therefore mean that we also share this attribute. Young children demonstrate most vividly an inherent creative capacity. And then they encounter television and a static, colorless educational system. What remains of the creative gift after these cannot be safely predicted.

Animals are not creative—rather, they are instinctive. For this reason, the beaver dams, bird nests, and ant hills of the 1980s are no different from those of the 1580s. But as humans we can create entirely new models. We can take the raw materials given to us by God and arrange them in a pattern that bears the stamp of an individual creative mind. Taking words, colors, clay, musical notes, bricks, or marble, a man or woman may shape something that has never been. We find such activity "fulfilling." Why? Because we are living up to the image of God woven deep in our inmost being.

We Are God's

The fact that we are in the image of God means even more than the above considerations. It also suggests *ownership.* His ownership. His right to all that I am.

An incident from the life of Jesus illustrates this truth. He was asked if it was lawful to pay taxes to Caesar. A legitimate question, perhaps, but in its setting it was nothing more than a ver-

bal trap. A trap with iron springs and deadly teeth. If He said "yes" He could be considered a traitor to His own people. But if He said "no" He could be condemned as a traitor to the government of Rome.

He said neither.

Instead, He called for a coin. Holding it up for all to see, He asked a question of His own.

"Whose image—whose likeness—is on this coin?"

The reply was instantaneous. "Caesar's!"

Jesus agreed, and then added, "Render unto Caesar that which is Caesar's and unto God that which is God's."

When Jesus said the words, "Whose image . . ." his listeners would have immediately recognized another level of significance to the term. From childhood they had learned that they were created *in the image of God.* No more even needed to be said. If Caesar's image on the coin denoted Caesar's *ownership* and the bearer's *stewardship* of the coin, then God's image on their individual lives denoted the very same thing: His ownership, their stewardship. So render to Caesar, said the Nazarene, that which is his: the coin. But at the same time, give to God that which is His due: your very life.

Until we acknowledge this basic fact of human existence, we can never become what He had in mind for us to become. We can never know our true humanity. As the only creatures whose being is not in themselves, we are human only to the extent that we respond to our God. To fail in this is to deny our humanity. It is to become something less than a woman, something less than a man.

We Are Male and Female

The uniqueness of humans is cited in even more ways in these Genesis verses. In our wholeness we are "male and female." In other words, just as we are incomplete when we are without God, we are also incomplete when we are alone, without others. More specifically, our incompleteness seems to pertain to our sexuality. It is the couple, man and woman together, that reflects what God is really like. As such, they are to "be fruitful and multiply" via the creative act of love and as co-creators with God.

No, babies are not dropped from heaven, nor are they delivered by the stork or found by the swamp. They are created by mothers and fathers who are in the image of God. And God is love.

We Are Trusted

In what must be seen as a highly risky act, God gave humans dominion over the earth—a position of phenomenal trust and vast responsibility. Such a responsibility could only be shared with those who would be co-creators with Him—those who would share a tender love and appreciation for the work of His hands.

The present ravished condition of much of our earth reveals how far that level of apprecia-

tion—and sense of responsibility—has fallen. In earlier chapters we marveled at the function and beauty of God's creation, but now much of that beauty has been blotched and blighted. Functions of nature that have operated with exquisite precision for millenniums on end are being warped and distorted through the heedless tampering of men. Self-correcting, self-protecting systems are breaking down in the face of man's blatant refusal to take God's command of stewardship seriously. When the Creator granted man "dominion," He never intended it to mean a license for destruction.

We Are Very Good

Whatever the human being becomes, we must remember that God started us out as "very good." He exalted us by making us the crown of His creation, molding us in His very image and then declaring us very good along with the rest of His handiwork. To harm, kill, or dehumanize a human being in any way is an act of serious concern in the eyes of the Creator.

There are those who fear that acknowledging these human attributes is dangerous. Such recognition, they caution, might divert our rightful worship from God to fellow human beings. Yet the writer of Psalm 8 did not seem at all reluctant to celebrate a high view of humankind.

> *"Thou hast made him (man) little*
> > *less than God,*
> > *and dost crown him with glory*
> > *and honor.*
> *Thou hast given him dominion*
> > *over the works of thy hands;*
> > *thou hast put all things under his feet,*
> *all sheep and oxen,*
> > *and also the beasts of the field,*
> *the birds of the air, and the fish of the sea,*
> *whatever passes along the paths of the sea."*

But this is not where the psalmist stops!

> *"O LORD, our LORD,*
> > *how majestic is thy name in all the earth!"*

The ancient poet remembers who made us—who it was who crowned us with glory and honor. It is only when we forget our Maker that we deify man.

In Heinz Seelig's painting we see all things in their proper place, and God over all. Truly, it is very good.

There is just one thing that cannot be seen in the painting, that might distort the surrounding goodness of the scene. It is not the tree next to Adam and Eve—which is delightful to the eyes.

No. It is the choice that would be made about the tree . . . a choice that can be seen through the anguished centuries of human history. A choice about that one beautiful, beautiful tree. . . .

On Creation's seventh day,
man's first full day
and God's Nth day
He rested.

Modeling for us
the importance of taking time
to restore our energies
revive our spirits
and recreate our goals.

And to remember
who made us,
loves us,
and sustains us.

"Bless the LORD, *O my soul;*
and all that is within me,
bless his holy name!
Bless the LORD, *all his works,*
in all places of his dominion.
Bless the LORD, *O my soul!"*
(Psalm 103:1, 22)

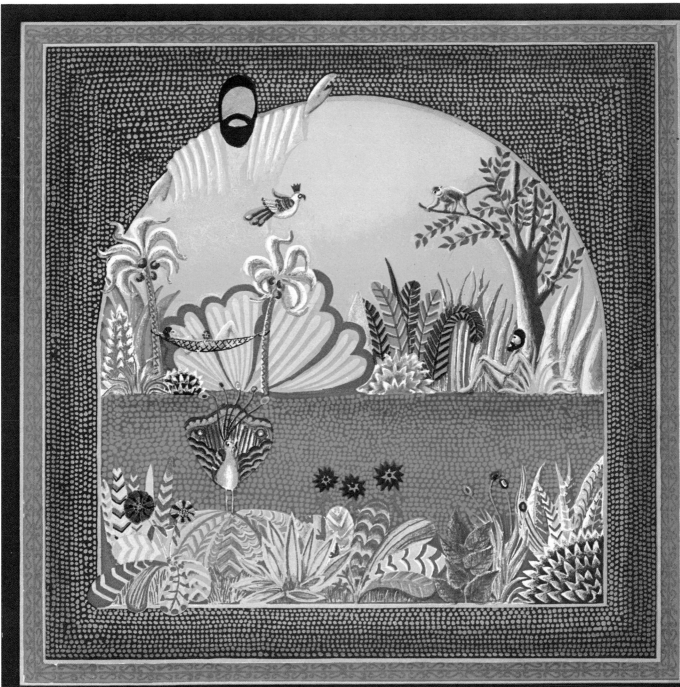

ויכל אלהים ביום השביעי מלאכתו
אשר עשה. וישבת ביום השביעי מכל
מלאכתו אשר עשה.

And on the seventh day God ended his work
which He had made; and He rested on the
seventh day from all his work which He had
made.

The Seventh Day

"And on the seventh day God finished his work which he had done, and he rested on the seventh day from all his work which he had done. So God blessed the seventh day and hallowed it, because on it God rested from all his work which he had done in creation" (Genesis 2:2-3).

Genesis doesn't say what little finishing touches God may have made.

Who knows, He may have decided Adam would look better with a beard or the giraffe's neck might need to be extended just a little. Maybe He stoked up the sun a little bit hotter or checked the aerodynamics of the bumblebee—just one more time. He could have added a little more jump to the frog and even considered starting over on the crocodiles. Whatever, He finished!

What a sense of accomplishment, fulfillment, and completion the Creator must have felt. Not that He would now simply sit back and have nothing to do with His creation; He would always be involved in His loving and caring way. But now it was all together and working, spinning, breathing, breeding, expanding . . . living.

He was very pleased and now He was going to enjoy what His hands had formed. As a matter of fact, He scheduled a whole day of rest precisely for that purpose. Just as any artist or craftsman would find pleasure in standing back and drinking in the full significance of a just-completed work, so this great Creator would experience His creation.

I have known some folks in my time who would be a little disappointed in God if they discovered He rested. Even Archie Bunker, who normally accepts anything which is written in the Bible, questions the idea of God resting. He feels, personally, that God did not rest at all, but if He did it was no more than half a day.

For Archie and his kind, rest is a sign of weakness. These are the same individuals who think play is only for children, laughter is for the immature, joy is for the irreligious, and celebration is for heathens. Those who subscribe to the workaholic mentality usually end up planted under an epitaph by which they would be honored: "He worked himself to death."

Praise God for those who labor but may God help them to learn that working is only one petal in the full-bloomed life. There are other petals which add to life's beauty and wholeness. A fully-functioning person recognizes the *rhythm* of life. We see it whether we look outward to nature or inward to ourselves. There is a rhythm in the movement of the stars, the changing of the seasons, the beating of our hearts, and the expansion and contraction of our lungs. Even though we are insensitive to it, there is a rhythmic hum which penetrates both the atom and the galaxy. When the "trees clap their hands," as the psalmist suggests, it is because they have caught the rhythm of God's universe. Life has an unmistakable swing built into its very essence, and if we fail to enjoy this experience called "living" it is because we are out of sync.

But how does one stay in sync?

Creation's day seven speaks eloquently to that question. According to Genesis, the rhythm between work and rest, labor and leisure, has a distinct "six-one" beat: six days of toil, and one day of rest. This, at least, seems to be God's rhythm and one which He will later establish as a standard for His people.

But in the case of the new humans, freshly-created, their first full day is a holiday. Work comes later. Anthropologists tell us that we were singers and dancers long before we became the master builders that recent history shows us to be. This fact affirms the sequence of our first day on God's new, green world.

It is partly because we are singers and dancers that the early celebrations of the Old Testament Sabbath were associated with joy and mirth. In Hosea 2:11, when God speaks of putting an end to mirth, He specifically states that this would mean the end of the Sabbath. Again in Psalm 92, a special Sabbath song, the mood is definitely upbeat:

> *"For thou, O LORD, hast made me glad by thy work;*
> *at the works of thy hands I sing for joy."*

There have been long, gray periods of history when the observance of the Sabbath became a matter of pale legalism, drained of vitality, devoid of joy. During such epochs the Sabbath became little more than another dreary burden. But then whenever revival and renewal came to the people, joy returned to the Sabbath.

What then are we to do on the Sabbath?

First of all, we must be free to do nothing. Or, in the words of an eastern mystic, "Don't just do something, stand there."

One of the ways we get to know God, Scripture suggests, is by simply being still—no mean task for these latter days of the twentieth century. The full-throttle sense of time built into our economic and social systems keeps our motors spinning so fast that living degenerates into a frenzied blur. Obsessed by goals and destinations, we have little time for the scenery along the way.

True Sabbath, for most of us, would have to begin with a prayer similar to the one offered by this anonymous writer.

"Slow me down, Lord! Slow me down!
Ease the pounding of my heart by the quieting of my mind. Steady my hurried pace with a vision of the eternal reaches of time.
Slow me down, Lord!
Give me, midst the confusion of my day, the calmness of the everlasting hills. Break the tension of my nerves and muscles with the soothing music of the singing streams that live in my memory.

Slow me down, Lord!
Help me to know the magic restoring power of sleep and faith in God. Teach me the art of taking minute vacations, of slowing down to look at a flower, to chat with a friend, to pat a dog, to read a few lines of the Good Book.

Slow me down, Lord!
Remind me each day of the fable of the hare and the tortoise that I may know that the race is not always to the swift; that there is more to life than increasing its speed.

Slow me down, Lord!
Let me look upward into the branches of the towering oak and know that it grew because it grew slowly and well.

Slow me down, Lord!

And inspire me to send my roots deep into the soil of life's enduring values that I may grow toward the stars of a greater destiny.

Slow me down, Lord!"

The writer of this prayer is wise in realizing there are some gifts God has for us which we cannot receive until we slow down. Having done so, we may enter into the incomparable Sabbath benefits of renewal, re-creation, and restoration. Beyond these, we will also have the opportu-

nity to reflect on good gifts of the past. Life's hurried pace causes us to forget, so we must have Sabbath stops for remembering who we are . . . and to Whom we belong.

Some folks in Holland call the Sabbath "God's Dyke." A helpful analogy. The dyke is a protective sea wall that holds back the surging waves and allows people to live in areas that would otherwise be utterly uninhabitable. The Sabbath is like that. Just like a dyke keeps the quiet Holland farmlands from being engulfed by the Atlantic, a day of rest can keep us from being engulfed by destructive value systems and the corrosive pressures of contemporary society. Humans are such pliable creatures. Immersed in the push-and-shove of daily living, we are in danger of being squeezed into a misshapen caricature of what God intended us to become. The Sabbath is God's opportunity to remold us into His image.

With so many bent on reducing our world to spiritual shambles, there has to be a place where we can find refuge. A place where the priorities of living are justice and righteousness rather than self and success. A place where cooperation is valued over competition, beauty over chaos, health over indulgence, love over bigotry, and family over fame. A place where bread is better than bombs, sacrifice is better than gluttony, sharing is better than hoarding, and good news stirs more excitement than bad news.

The Sabbath is such a place.

It is worthwhile to be reminded that the Sabbath is not just for our benefit. It is a day for the worship of God. And yet even though our worship is directed toward Him, we still reap personal gain from the experience. Worship, like love, benefits both the giver and receiver. Nevertheless, let there be no mistake, the end of worship is God, the Creator. The late William Temple affirms this point. "To worship," he says, "is to quicken the conscience by the holiness of God, to feed the mind with the truth of God, to purge the imagination with the beauty of God, to open the heart to the love of God, to devote the will to the purpose of God. All this is gathered up in that emotion which most cleanses us from selfishness because it is the most selfless of all emotions—adoration."[7]

The words "Sabbath" and "rest" belong to the same family of words which also includes "peace." There is a real sense in which the first Sabbath, as it is portrayed in Heinz Seelig's painting, is a "peace day." It contains all the ingredients of the concept clothed by that beautiful Hebrew word *shalom,* which we translate "peace." But *shalom* has a rich tapestry of meaning that also suggests totality, well-being, and harmony. Also included within this single word's embrace are the concepts of prosperity, happiness, and community.

It is the way God intends things to be. On that first Sabbath His Creation was bathed with *Shalom.* And in the fulness of His time we await the day when peace, His peace, will reign anew.

It was significant, and perhaps even prophetic, that during the time of Israel's peace negotia-

tions at Camp David, the participants of the Accord each received Heinz Seelig's paintings of the Creation—the last time on earth when there was peace. Since that time it has only been a dream. But what a beautiful dream it is.

"The wolf shall dwell with the lamb,
and the leopard shall lie down with the kid,
and the calf and the lion and the fatling
together,
and a little child shall lead them.
The cow and the bear shall feed;
their young shall lie down together;
and the lion shall eat straw like the ox.
The sucking child shall play over the
hole of the asp,
and the weaned child shall put his
hand on the adder's den.
They shall not hurt or destroy
in all my holy mountain;
for the earth shall be full of the
knowledge of the LORD
as the waters cover the sea."
(Isaiah 11:6-9)

Could it be?

Yes, *". . . for he will speak peace to his*
people,
to his saints, to those who turn
to him in their hearts.
Surely his salvation is at hand for
those who fear him,
that glory may dwell in our
land.

Steadfast love and faithfulness
will meet;
righteousness and peace will
kiss each other."
(Psalm 85:8-10)

71

Until then, let there be joy. The painting we have of the seventh day shows, I believe, Adam,

Eve, and God in the morning. Surely on that Sabbath afternoon there was music, dancing, and great celebration over the wondrous acts of the mighty Creator God. The trees clapped their hands, the mountains skipped like rams, and all good things sang!

FOOTNOTES

1. Alfred Jospe and Richard N. Levy, *Bridges to a Holy Time* (New York: KTAV Publishing House, 1973), p. 251.

2. C. S. Lewis, *The Dark Tower and Other Stories,* ed. Walter Hooper (New York and London: Harcourt, Brace & Jovanovich, 1977), p. 100.

3. Lewis Thomas, *Lives of a Cell: Notes of a Biology Watcher* (New York: Viking Press, 1974), p. 171.

4. William A. Shurcliff, *New Inventions in Low-Cost Heating: One Hundred Daring Schemes Tried and Untried* (Andover, Massachusetts: Brick House Publishing Co., 1970), p. 245.

5. Jospe and Levy, *Bridges to a Holy Time,* p. 251.

6. Robert Bridges, *A Testament of Beauty* (New York and London: Harcourt, Brace & Co.), quoted in D. T. Niles, *Studies in Genesis* (Philadelphia: Westminster Press, 1958), p. 59.

7. William Temple, *The Hope of a New World* (New York: Arno Press, 1940), p. 30.